4-22-12

To Jason, Kreystle, & Isaac,

 We love you so much, and
we wish you happy days and
peaceful sleep always.

 Love always,
 Mom & Dad
 (Cheryl & Sonny)
 Grandma & Grandpa

Goodnight Baby

To our new babies: Kole & Audree,
you are perfect additions to our families.

Published by Sellers Publishing, Inc.

Photography © 2012 Ryden-Raver LLC

Sellers Publishing, Inc.
161 John Roberts Road, South Portland, Maine 04106
Visit our Web site: www.sellerspublishing.com
E-mail: rsp@rsvp.com

ISBN 13: 978-1-4162-0657-6

10 9 8 7 6 5 4 3 2 1

Printed and bound in China.

Goodnight Baby

LULLABIES OF PEACE & LOVE

Photography by Tracy Raver & Kelley Ryden

SELLERS

PUBLISHING

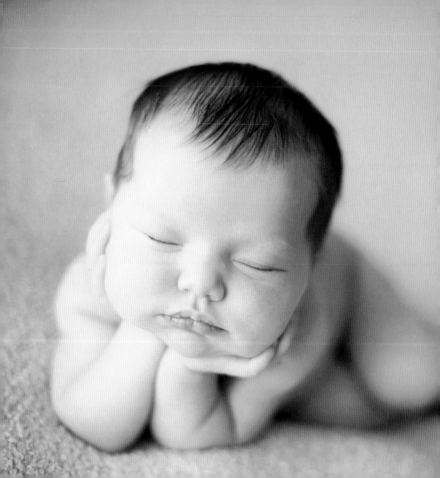

A Candle, A Candle

A candle, a candle
To light me to bed;
A pillow, a pillow
To tuck up my head.
The moon is as sleepy as sleepy can be,
The stars are all pointing their fingers at me,
And Missus Hop-Robin, way up in her nest,
Is rocking her tired little babies to rest.
So give me a blanket
To tuck up my toes,
And a little soft pillow
To snuggle my nose.

AUTHOR UNKNOWN

Too-Ra-Loo-Ra-Loo-Ral

Over in Killarney / Many years ago / Me mither sang a song to me
In the tones so sweet and low.
Just a simple little ditty / In her good ould Irish way,
And I'd give the world if she could sing
That song to me this day.
Too-ra-loo-ra-loo-ral, Too-ra-loo-ra-li, Too-ra-loo-ra-loo-ral,
Hush, now don't you cry!
Too-ra-loo-ra-loo-ral, Too-ra-loo-ra-li, Too-ra-loo-ra-loo-ral,
That's an Irish lullaby.
Oft, in dreams I wander
To that cot again / I feel her arms a huggin' me
As when she held me then. And I hear her voice a hummin'
To me as in days or yore, When she used to rock me fast asleep
Outside the cabin door.
Too-ra-loo-ra-loo-ral, Too-ra-loo-ra-li, Too-ra-loo-ra-loo-ral,
Hush, now don't you cry!
Too-ra-loo-ra-loo-ral, Too-ra-loo-ra-li, Too-ra-loo-ra-loo-ral,
That's an Irish lullaby.

J.R. SHANNON

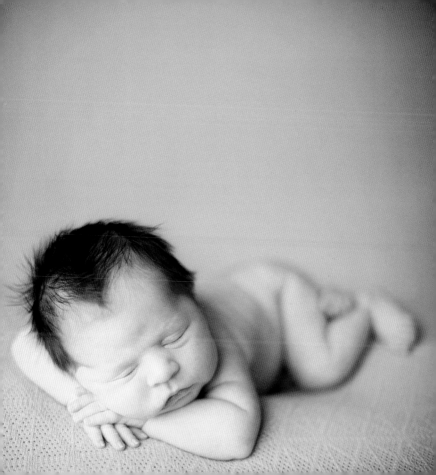

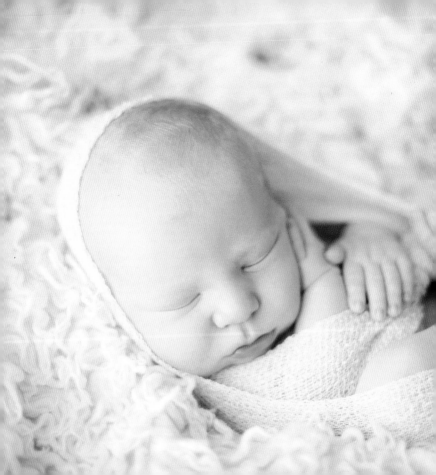

Cradle Song
(GOLDEN SLUMBERS)

Golden slumbers kiss your eyes,
Smiles await you when you rise.
Sleep, pretty baby,
Do not cry,
And I will sing a lullaby.

Care you know not,
Therefore sleep,
While I o'er you watch do keep.
Sleep, pretty darling,
Do not cry,
And I will sing a lullaby.

THOMAS DEKKER

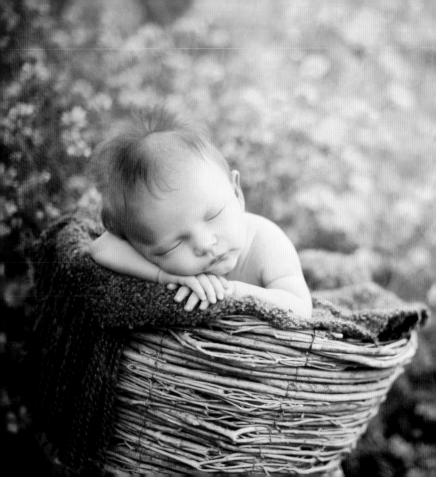

Autumn Lullaby

The sun has gone from the shining skies
Bye, baby, bye
The dandelions have closed their eyes
Bye, baby, bye
The stars are lighting their lamps to see
If babes and squirrels and birds and bees
Are sound asleep as they ought to be
Bye, baby, bye.

The squirrel keeps warm in his furs of gray
Bye, baby, bye
'Neath feathers, birdies are tucked away
Bye, baby, bye
The robin's home is a nest o'erhead
The bees, they nest in a hive instead
My baby's nest is her little bed
Bye, baby, bye.

AUTHOR UNKNOWN

A Basque Lullaby

Lullaby, twilight is spreading
Silver wings over the sky;
Fairy elves are softly treading,
Folding buds as they pass by.
Lullaby, whisper and sigh,
Lullaby, lullaby.

Lullaby, deep in the clover
Drone the bees softly to rest;
Close white lids your dear eyes over,
Mother's arms shall be your rest.
Lullaby, whisper and sigh,
Lullaby, lullaby.

AUTHOR UNKNOWN

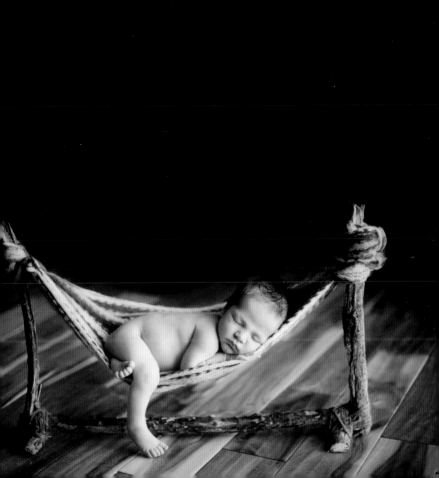

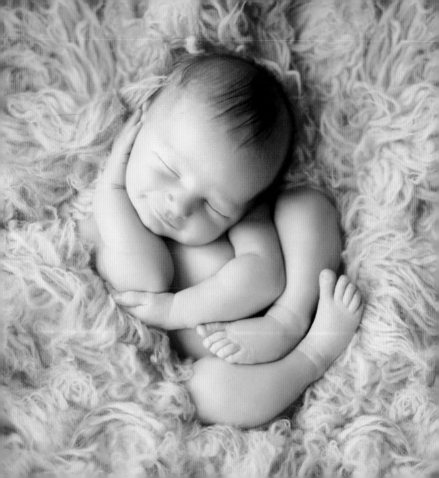

Hush, Little Baby

Hush, little baby, don't say a word,
Mama's going to buy you a mockingbird.
If that mockingbird won't sing,
Mama's going to buy you a diamond ring.
If that diamond ring turns brass,
Mama's going to buy you a looking glass.
If that looking glass gets broke,
Mama's going to buy you a billy goat.
If that billy goat won't pull,
Mama's going to buy you a cart and bull.
If that cart and bull turn over,
Mama's going to buy you a dog named Rover.
If that dog named Rover won't bark,
Mama's going to buy you a horse and cart.
If that horse and cart fall down,
You'll still be the sweetest little baby in town.
So hush little baby, don't you cry,
Daddy loves you and so do I.

AUTHOR UNKNOWN

Day Is Done

Day is done,
Gone the sun,
From the lake, from the hills, from the sky.
All is well, safely rest,
God is nigh.

AUTHOR UNKNOWN

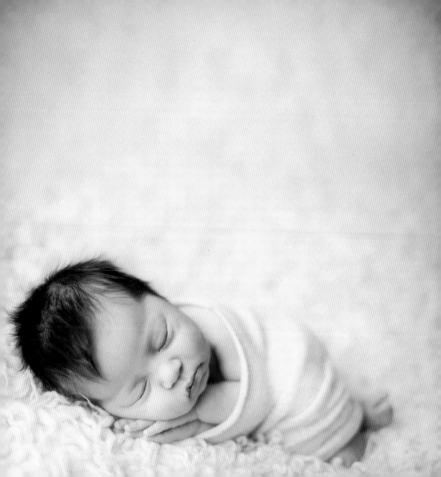

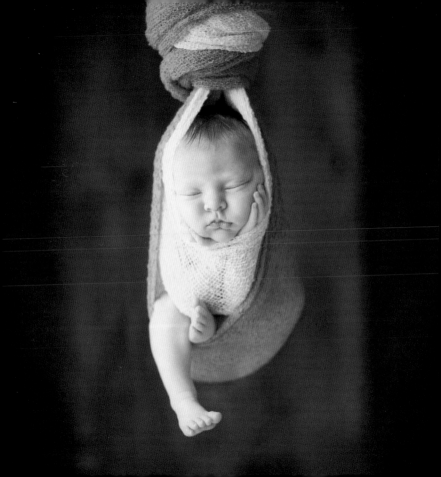

Now the Day Is Over

Now the day is over
Night is drawing nigh
Shadows of the evening
Steal across the sky

Now the darkness gathers
Stars begin to peep
Birds and beasts and flowers
Soon will be asleep

Now the day is over
The sun has said goodnight
The crescent moon has risen
To share its gentle light

Now the wind is whispering
In stillness soft and sweet
All of nature's creatures
Now are sound asleep

The birds and beasts and flowers
All have gone to sleep

SABINE BARING-GOULD

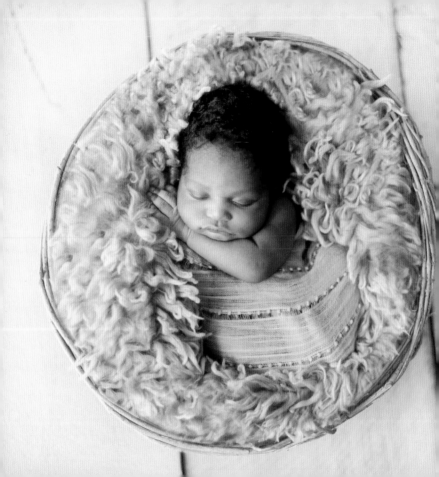

Angels Watching Over Me

All night, all day,
Angels watching over me, my Lord.
All night, all day,
Angels watching over me.

Sun is a-setting in the West;
Angels watching over me, my Lord.
Sleep my child, take your rest;
Angels watching over me.

All night, all day,
Angels watching over me, my Lord.
All night, all day,
Angels watching over me.

AUTHOR UNKNOWN

Japanese Lullaby

Sleep, little pigeon,
And fold your wings,
Little blue pigeon
With velvet eyes;
Sleep to the singing
Of mother-bird swinging —
Swinging the nest
Where her little one lies.

Away out yonder
I see a star,
Silvery star
With a tinkling song;
To the soft dew falling
I hear it calling —
Calling and tinkling
The night along.

In through the window
A moonbeam comes,
Little gold moonbeam
With misty wings;
All silently creeping,
It asks "Is he sleeping —
Sleeping and dreaming
While mother sings?"

But sleep, little pigeon,
And fold your wings,
Little blue pigeon
With mournful eyes;
Am I not singing? —
See, I am swinging —
Swinging the nest
Where my darling lies.

AUTHOR UNKNOWN

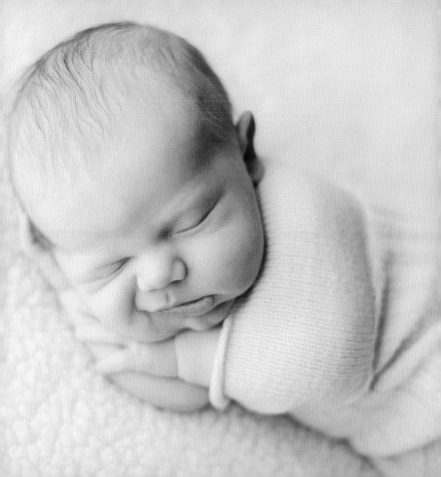

Our Baby

Cheeks of rose, tiny toes,
Has our little baby;
Eyes of blue, fingers too,
Cunning all as may be.

Mouth so fair, skin so clear,
Just as soft as may be;
Bonny eyes, looking wise,
Such a precious baby.

Thee I love, sweetest dove,
Darling little baby!
While I live, thee I'll give
Kisses warm as may be.

Crow and play all the day,
Happy little baby!
May your life, free from strife,
Pure as 'tis today be.

AUTHOR UNKNOWN

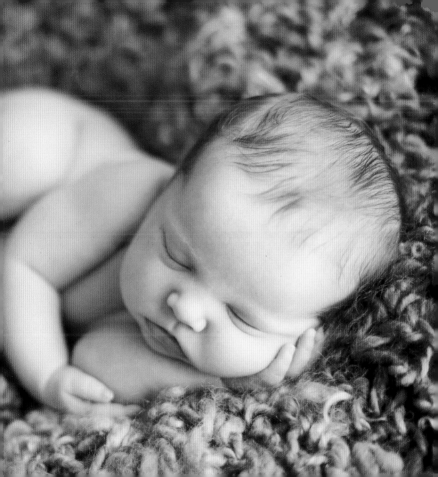

I See the Moon

I see the moon
The moon sees me
The moon sees the one
I long to see

God bless the moon
And God bless me
And God bless the one
I long to see

Seems to me
That God above
Created you
For me to love

He picked you out
From all the rest
'Cause He knew
I loved you best.

AUTHOR UNKNOWN

Dream Fairy

A little fairy comes at night,
Her eyes are blue, her hair is brown,
With silver spots upon her wings,
And from the moon she flutters down.

She has a little silver wand,
And when a good child goes to bed,
She waves her hand from right to left,
And makes a circle round its head.

And then it dreams of pleasant things,
Of fountains filled with fairy fish,
And trees that bear delicious fruit,
And bow their branches at a wish.

AUTHOR UNKNOWN

Skidamarink

Skidamarink a dink a dink,
Skidamarink a doo,
I love you.
Skidamarink a dink a dink,
Skidamarink a doo,
I love you.

I love you in the morning
And in the afternoon,
I love you in the evening
And underneath the moon;
Oh, Skidamarink a dink a dink,
Skidamarink a doo,
I love you!

AUTHOR UNKNOWN

Little Fish

The crew is asleep
And the ocean's at rest;
I'm singing this song
To the ones I love best.

Hey ho, little fish,
Good night, good night,
Hey ho, little fish, good night.

The anchor's aweigh
And the weather is fine;
The Captain's on deck,
waltzing in time.

Hey ho, little fish,
Good night, good night,
Hey ho, little fish, good night.

You've been swimming all day,
In the ocean so wide;
Now it's time to rest,
And float with the tide.

Hey ho, little fish,
Good night, good night,
Hey ho, little fish, good night.

Hey ho, little fish,
Good night, good night,
Hey ho, little fish, good night.

AUTHOR UKNOWN

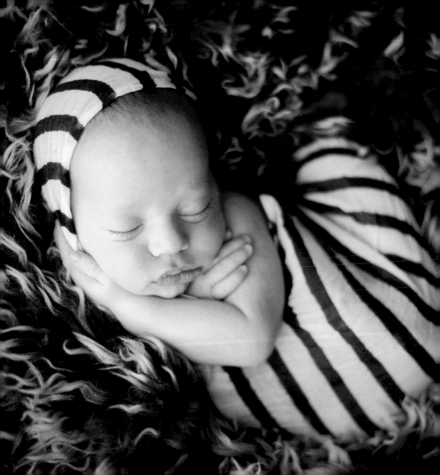

Dreams

May all your dreams bloom like daisies in the sun
May you always have stars in your eyes
May you not stop running on until your race is won
May you always have blue skies

A dream is something all your own to keep within your heart
To build on when you're glad or when your world's been torn apart
A dream is something all your own that no one else can steal
A dream is something you can make come real

May all your dreams bloom like daisies in the sun
May you always have stars in your eyes
May you not stop running on until your race is won
May you always have blue skies

Now you can share a laugh with any stranger on the street
And you can share your money with a beggar on the street
But you can only share your dream when love has set it free
So please, won't you share yours with me?

May all your dreams bloom like daisies in the sun
May you always have stars in your eyes
May you not stop running on until your race is won
May you always have blue skies

AUTHOR UNKNOWN

Winkum

Winkum, winkum, shut your eyes,
While I sing sweet lullabies,
For the dew is falling soft,
Lights are flick'ring up aloft,
And the moon is peeping over
Yonder hilltop, capped with clover.

Chickens long have gone to rest,
Birds lie snug within their nest,
And my darling soon will be
Sleeping like a chickadee;
For with only half a try,
Winkum, Winkum shuts her eyes.

AUTHOR UNKNOWN

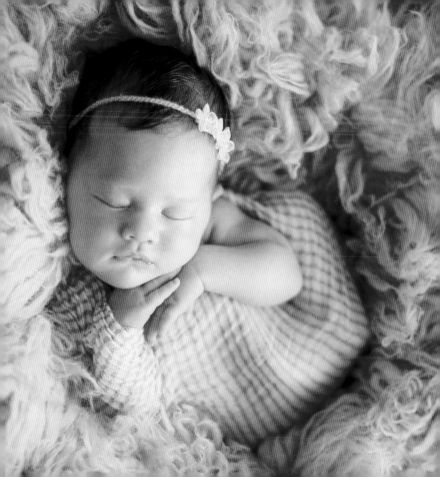

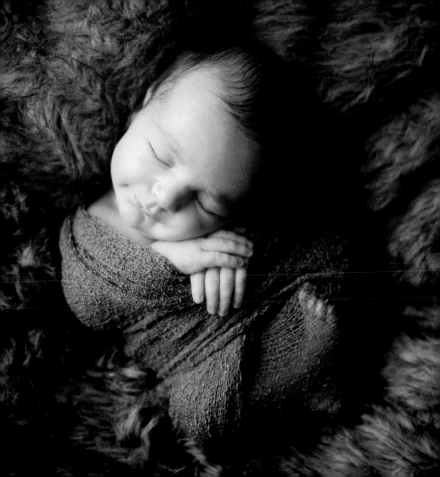

Come to the Window

Come to the window,
My baby, with me,
And look at the stars
That shine on the sea!

There are two little stars
That play bo-peep
With two little fish
Far down in the deep.

And two little frogs
Cry "Neap, neap, neap"
I see a dear baby
That should be asleep.

AUTHOR UKNOWN

Italian Cradle Song

Dormi, dormi, bel bambino,
Sleep on, O baby dearest,

Vago figlio del mio cor,
Thou darling of my heart;

La tua madre sta vicino,
Thy mother standeth near thee,

Tutta gioia tutt' amor.
All her love and joy thou art.

LUIGI RICCI

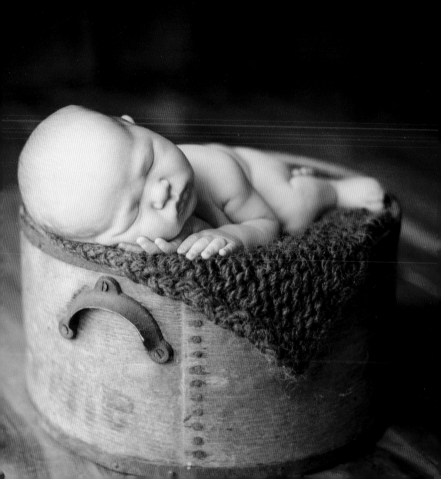

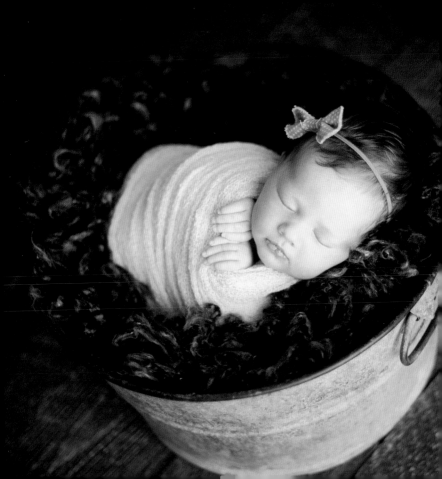

Mother's Song

There's not a rose where'er I seek
As comely as my baby's cheek.
There's not a comb of honey-bee,
So full of sweets as babe to me.
And it's O! sweet, sweet! and a lullaby.

There's not a star that shines on high,
Is brighter than my baby's eye.
There's not a boat upon the sea,
Can dance as baby does to me.
And it's O! sweet, sweet! and a lullaby.

No silk was ever spun so fine
As is the hair of baby mine.
My baby smells more sweet to me
Than smells in spring the elder tree.
And it's O! sweet, sweet! and a lullaby.

AUTHOR UNKNOWN

All Through the Night

Sleep my child and peace attend thee,
All through the night
Guardian angels God will lend thee,
All through the night
Soft the drowsy hours are creeping,
Hill and vale in slumber sleeping
I my loved ones' watch am keeping,
All through the night
Angels watching, e'er around thee,
All through the night
Midnight slumber close surround thee,
All through the night
Soft the drowsy hours are creeping,
Hill and vale in slumber sleeping
I my loved ones' watch am keeping,
All through the night

SIR HAROLD BOULTON

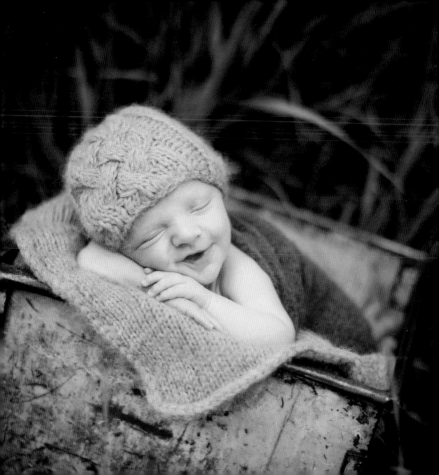

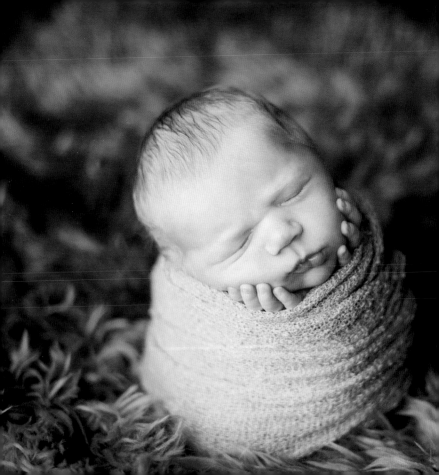

Wishing Poem

Star light,
Star bright,
First star
I see tonight

I wish I may,
I wish I might,
Have this wish
I wish tonight.

AUTHOR UNKNOWN

A Rocking Hymn

Sweet baby, sleep, what ails my dear?
What ails my darling thus to cry?
Be still, my child, and lend thine ear,
To hear me sing thy lullaby.

When God with us was dwelling here,
In little babes he took delight;
Such innocents as thou, my dear,
Are ever precious in His sight.

AUTHOR UKNOWN

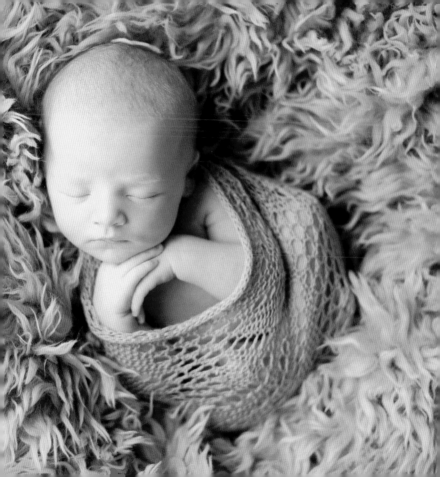

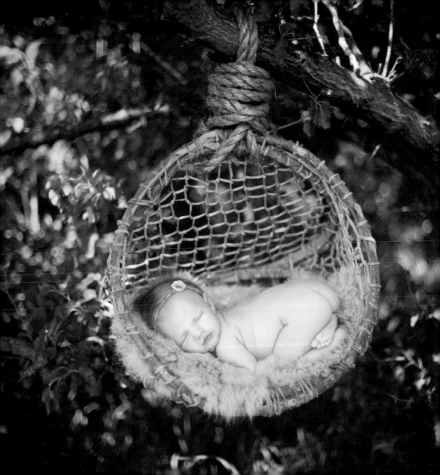

Rock-a-bye, Baby

Rock-a-bye, baby
In the treetop
When the wind blows
The cradle will rock
When the bough breaks
The cradle will fall
And down will come baby
Cradle and all

Baby is drowsing
Cosy and fair
Mother sits near
In her rocking chair

Forward and back
The cradle she swings
And though baby sleeps
He hears what she sings

From the high rooftops
Down to the sea
No one's as dear
As baby to me

Wee little fingers
Eyes wide and bright
Now sound asleep
Until morning light

AUTHOR UKNOWN

Down in the Valley

Down in the valley, valley so low
Hang your head over, hear the wind blow
Hear the wind blow, dear, hear the wind blow
Hang your head over, hear the wind blow.

Roses love sunshine, violets love dew
Angels in heaven know I love you
Know I love you, dear, know I love you
Angels in heaven, know I love you.

Writing this letter, containing three lines
Answer my question, "Will you be mine?"
"Will you be mine, dear, will you be mine?"
Answer my question, "Will you be mine?"

Down in the valley, valley so low
Hang your head over, hear the wind blow
Hear the wind blow, dear, hear the wind blow
Hang your head over, hear the wind blow.

AUTHOR UNKNOWN

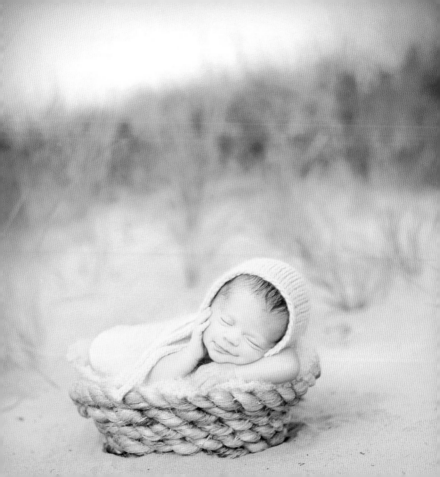

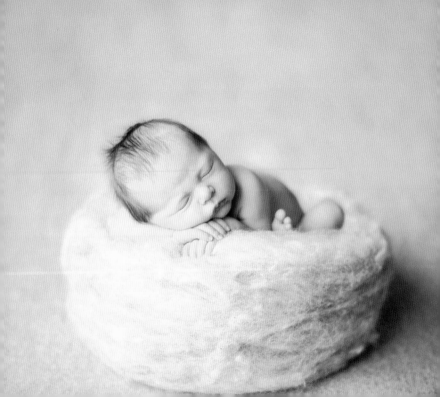

Bye, Baby Bunting

Bye, Baby Bunting,
Father's gone a-hunting,
Mother's gone a-milking,
Sister's gone a-silking,
Brother's gone to buy a skin
To wrap the baby bunting in.

MOTHER GOOSE

Beautiful Dreamer

Beautiful dreamer, wake unto me,
Starlight and dewdrops are waiting for thee;
Sounds of the rude world, heard in the day,
Lull'd by the moonlight have all pass'd away!
Beautiful dreamer, queen of my song,
List while I woo thee with soft melody;
Gone are the cares of life's busy throng,
Beautiful dreamer, awake unto me!
Beautiful dreamer, awake unto me!

Beautiful dreamer, out on the sea
Mermaids are chanting the wild lorelie;
Over the streamlet vapors are borne,
Waiting to fade at the bright coming morn.
Beautiful dreamer, beam on my heart,
E'en as the morn on the streamlet and sea;
Then will all clouds of sorrow depart,
Beautiful dreamer, awake unto me!
Beautiful dreamer, awake unto me!

STEPHEN C. FOSTER

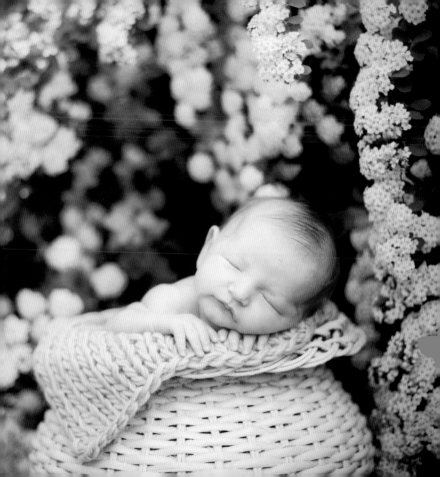

Twinkle, Twinkle, Little Star

Twinkle, twinkle, little star,
How I wonder what you are.
Up above the world so high,
Like a diamond in the sky.
Twinkle, twinkle, little star,
How I wonder what you are!

When the blazing sun is gone,
When he nothing shines upon,
Then you show your little light,
Twinkle, twinkle, all the night.
Twinkle, twinkle, little star,
How I wonder what you are!

Then the traveler in the dark
Thanks you for your tiny spark;
He could not see which way to go,
If you did not twinkle so.
Twinkle, twinkle, little star,
How I wonder what you are!

In the dark blue sky you keep,
While you thro' my window peep,
And you never shut your eye,
Till the sun is in the sky.
Twinkle, twinkle, little star,
How I wonder what you are!

JANE TAYLOR

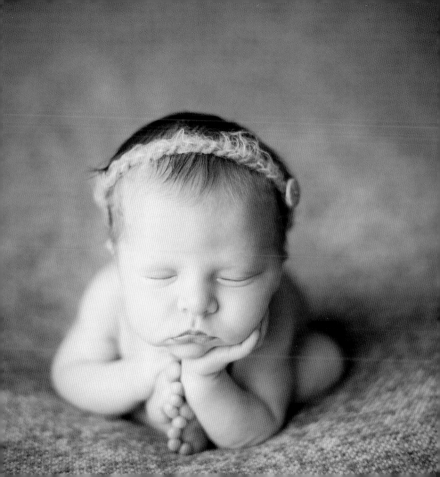

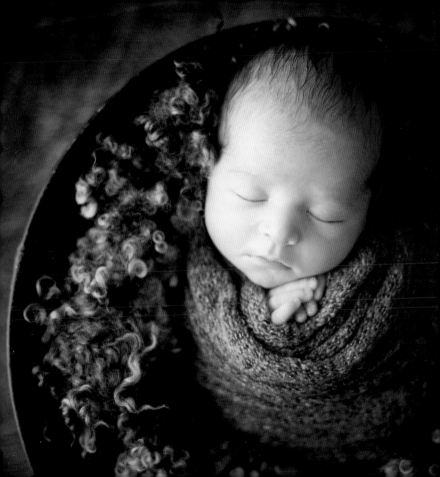

Lullaby and Goodnight

Lullaby and goodnight, with roses bedight
With lilies o'er spread is baby's wee bed
Lay thee down now and rest, may thy slumber be blessed
Lay thee down now and rest, may thy slumber be blessed

Lullaby and goodnight, thy mother's delight
Bright angels beside my darling abide
They will guard thee at rest, thou shalt wake on my breast
They will guard thee at rest, thou shalt wake on my breast

JOHANNES BRAHMS

Sleep, Baby, Sleep

Sleep, baby, sleep
Your father tends the sheep
Your mother shakes the dreamland tree
And from it fall sweet dreams for thee
Sleep, baby, sleep
Sleep, baby, sleep

Sleep, baby, sleep
Our cottage vale is deep
The little lamb is on the green
With snowy fleece so soft and clean
Sleep, baby, sleep
Sleep, baby, sleep

MOTHER GOOSE

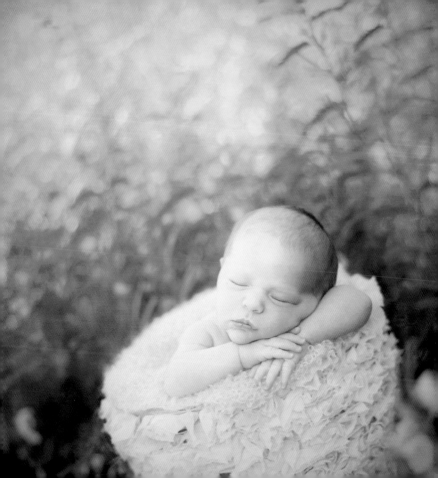